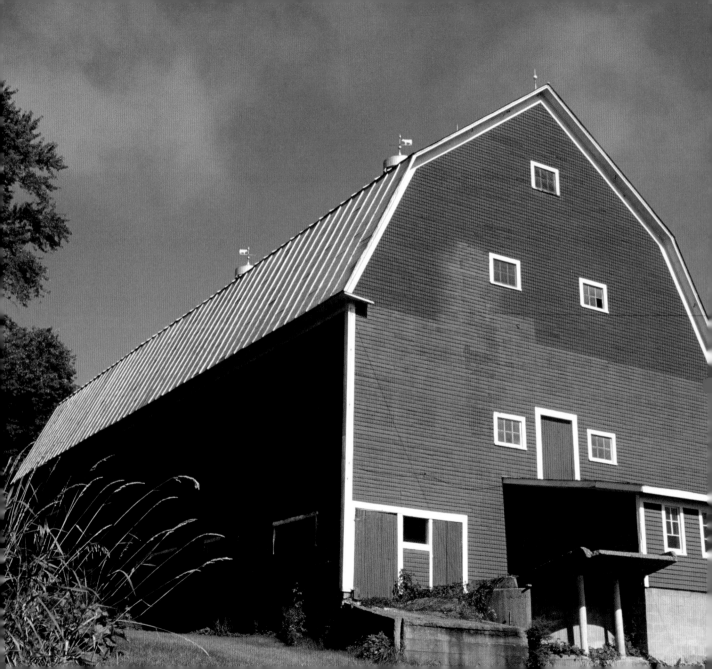

BARNS
OF NEW ENGLAND

Jeffrey E. Blackman

THE COUNTRYMAN PRESS
WOODSTOCK, VERMONT

ACKNOWLEDGMENTS

My sincere thanks go out to:
L & I Photo Labs, New York City
and
Brian Felice, timber framer

We welcome your comments and suggestions.
Please contact Editor, The Countryman Press,
P.O. Box 748, Woodstock, VT 05091,
or e-mail countrymanpress@wwnorton.com.

ISBN 978-0-88150-880-2

Book design and composition
by Eugenie S. Delaney

Published by The Countryman Press,
P.O. Box 748, Woodstock, Vermont 05091

Distributed by W. W. Norton & Company, Inc.,
500 Fifth Avenue, New York, NY 10110

Manufactured in China

10 9 8 7 6 5 4 3 2 1

FRONT COVER
WATERVILLE
Vermont

OVERLEAF
RYEGATE
Vermont

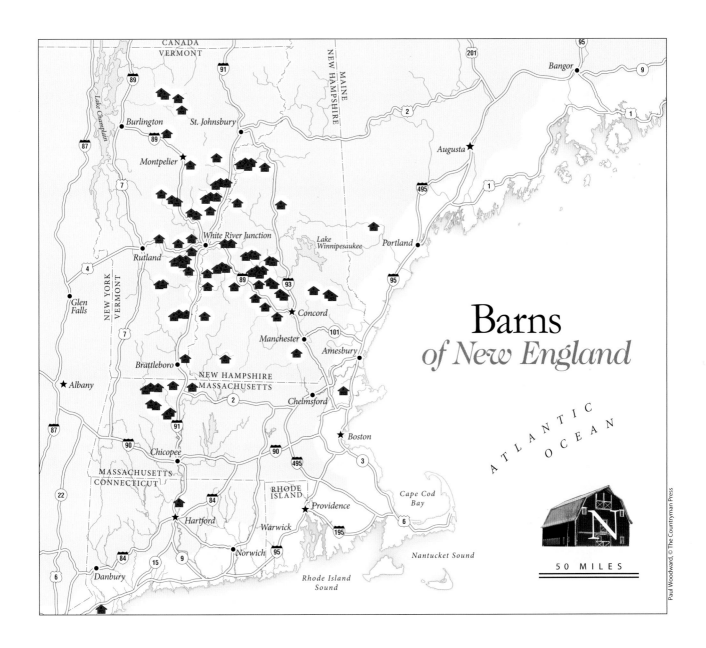

Barns
of New England

CANADA
VERMONT

MAINE
NEW HAMPSHIRE

Bangor

Lake Champlain

Burlington

St. Johnsbury

Montpelier

Augusta

White River Junction

Rutland

Lake Winnipesaukee

Portland

Glen Falls

NEW YORK
VERMONT

Concord

Manchester

Amesbury

Brattleboro

NEW HAMPSHIRE
MASSACHUSETTS

Albany

Chelmsford

Boston

MASSACHUSETTS
CONNECTICUT

Chicopee

RHODE ISLAND

ATLANTIC OCEAN

Cape Cod Bay

Providence

Hartford

Warwick

Nantucket Sound

Danbury

Norwich

Rhode Island Sound

50 MILES

Paul Woodward, © The Countryman Press

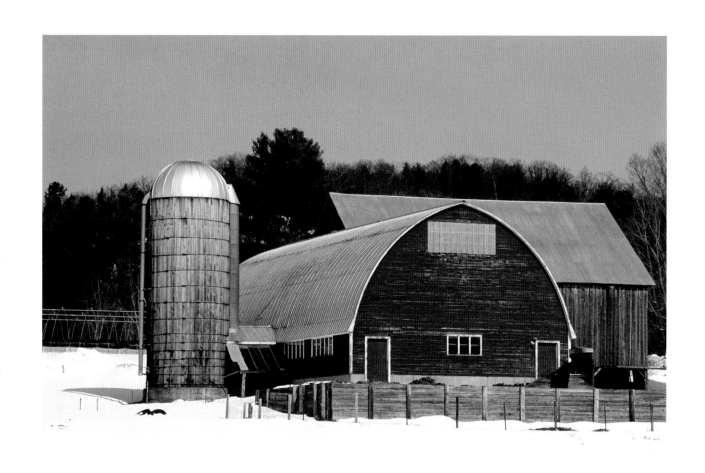

BRADFORD
Vermont

PREFACE

From Football Fields to a Barn in the Field

Years ago my dream was to build a home in New Hampshire or Vermont. I wanted land, open space, peace and quiet, nature—an environment opposite to the one I'd been in for so long as a professional sports photographer.

My quest for land to build on gave me a chance to capture photographically a subject that had begun to intrigue me as I wandered the New England countryside: the barn. Some barns were small, some large, some old, some new. There were red ones, brown ones; some that had been left to weather the elements. They came in all kinds of shapes; with windows and without. Some were set apart from houses and some were attached. Today the barn has taken on a new purpose: renovated, it becomes habitable by people.

I did finally build my home (after photographing hundreds and hundreds of college and professional football games). A post-and-beam house, it has, perhaps not surprisingly, a number of the same attributes as a barn.

All of the barns in this book were photographed:
- with film
- in natural light
- without filters
- without a tripod (all shots were taken with a hand-held camera)
- *without digital enhancements or alterations.*

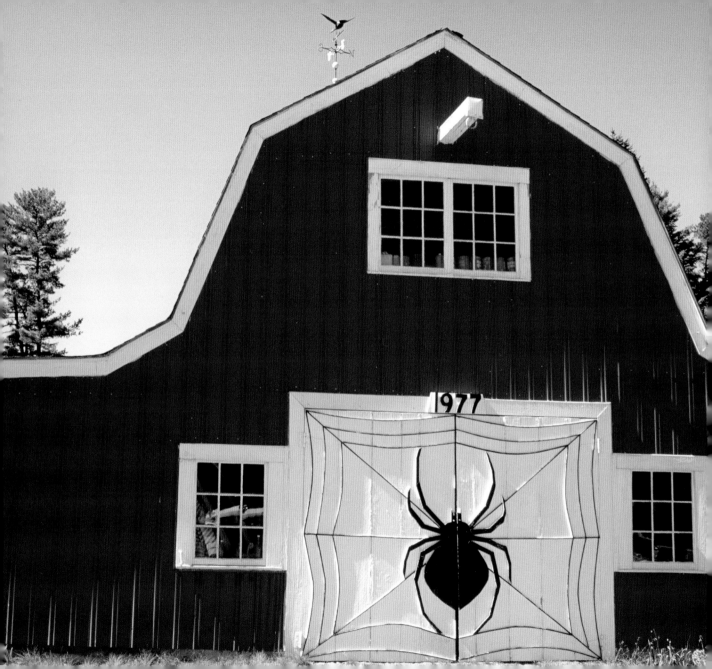

INTRODUCTION

Barns were introduced in America in the early 1700s, though they really started dotting the landscape in the 1900s. The first barns were put together with wooden pegs, a method that is still used today.

They vary greatly, not only in design but in the way they are situated on the land and oriented to the weather. A second level usually stores feed and displays the structure's greatest attribute, its height; New England barns soar 30 to 40 feet.

Barns were and are still used primarily for housing livestock and storing hay and grain for farming operations. Great favorites with mice, rats, raccoons, and other creatures looking for food and shelter, barns may also hold tractors, lawn mowers, snow plows, gardening equipment, and just plain junk.

Trying to find barns when you're out on a scenic drive could be a challenge. You might have better luck off the main roads or in winter, when there's less foliage in the way. There are numerous barns still being used for large- and small-scale farming, but they too, like the covered bridges of New England, another favorite photo subject of mine, are disappearing.

Enjoy,
Jeffrey Blackman

BARNSTEAD
New Hampshire

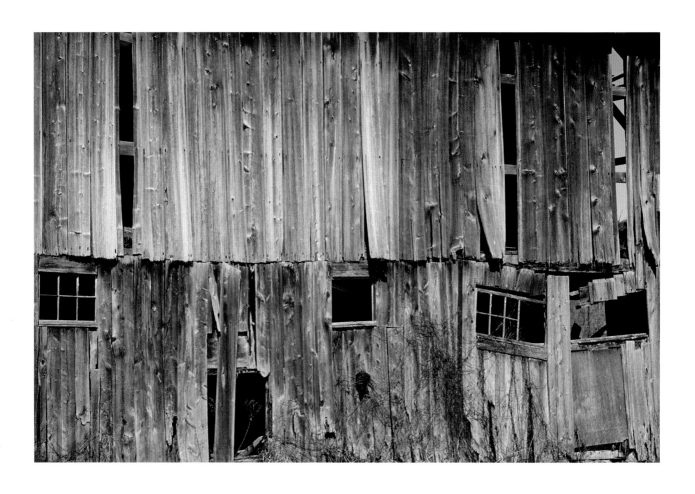

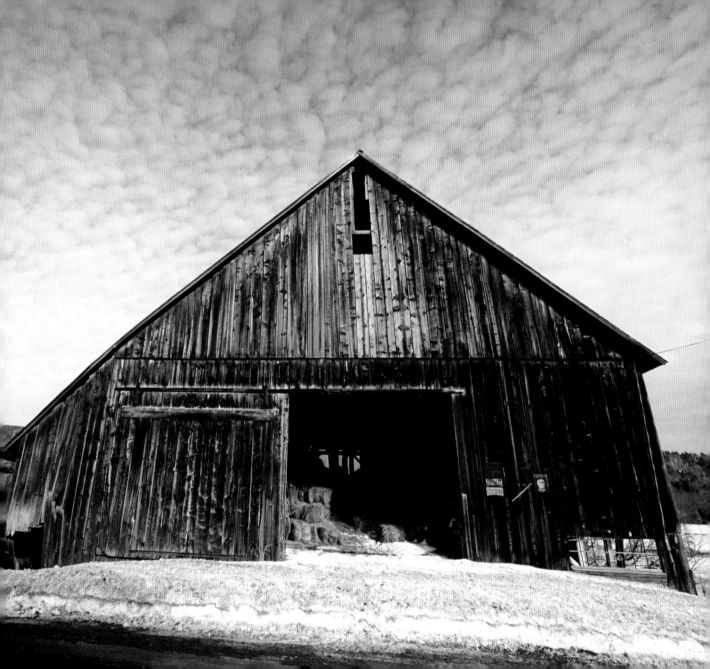

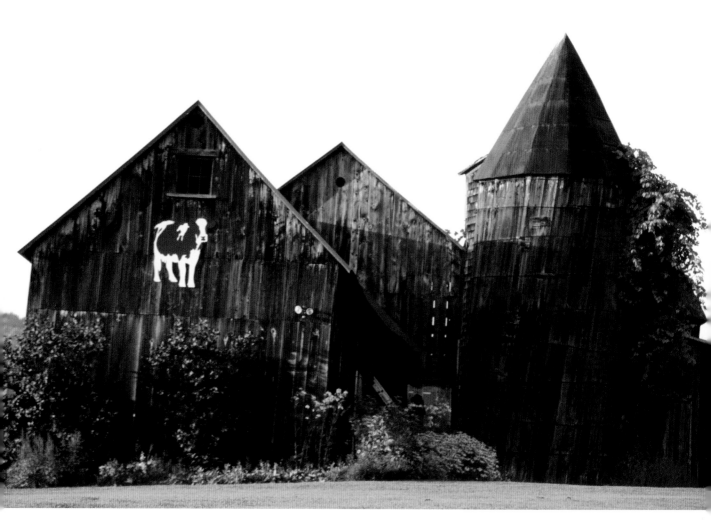

QUECHEE
Vermont

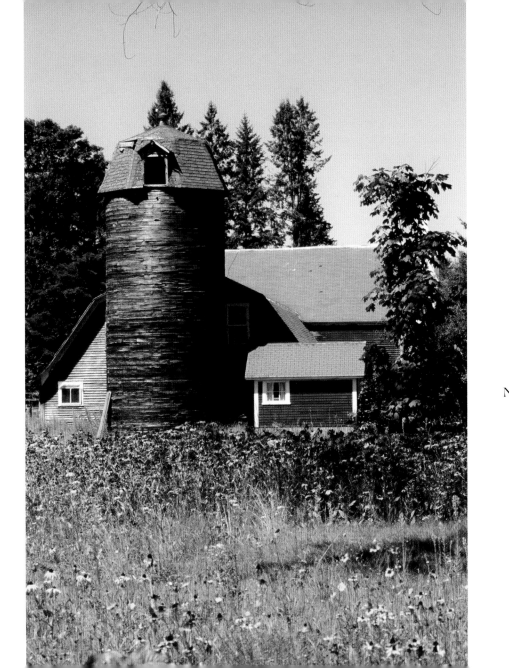

MONROE
New Hampshire

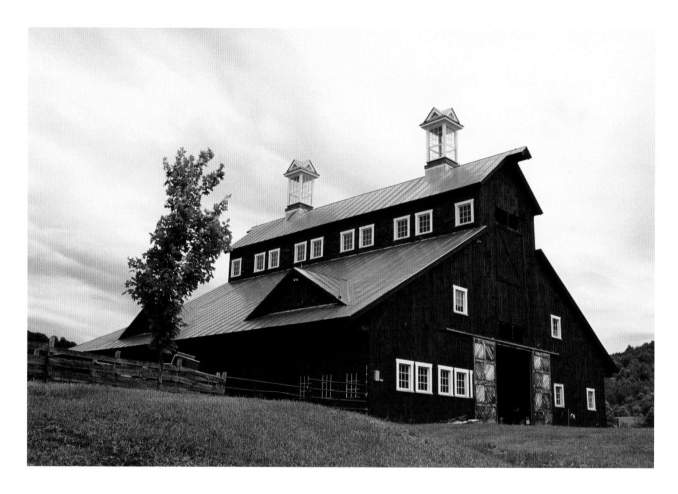

SOUTH ROYALTON
Vermont

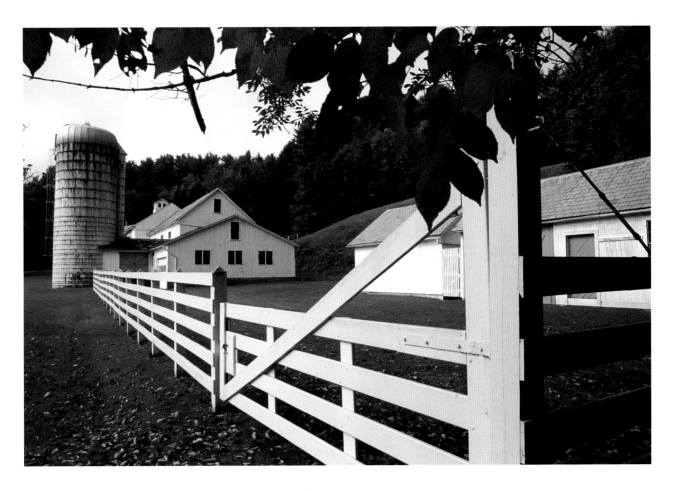

BERNARDSTON
Massachusetts

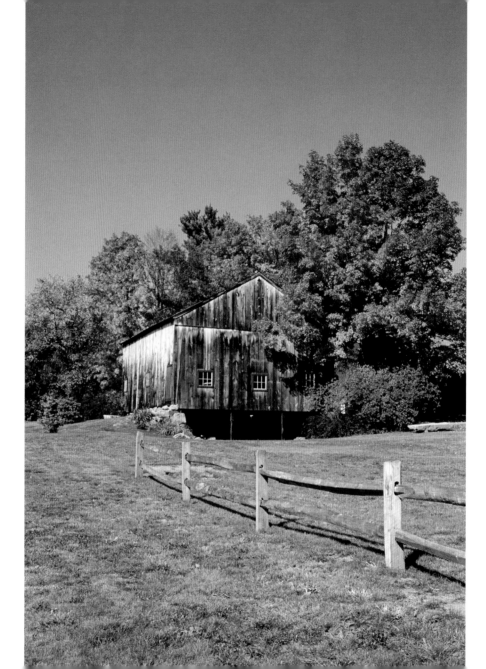

SWANZEY
New Hampshiret

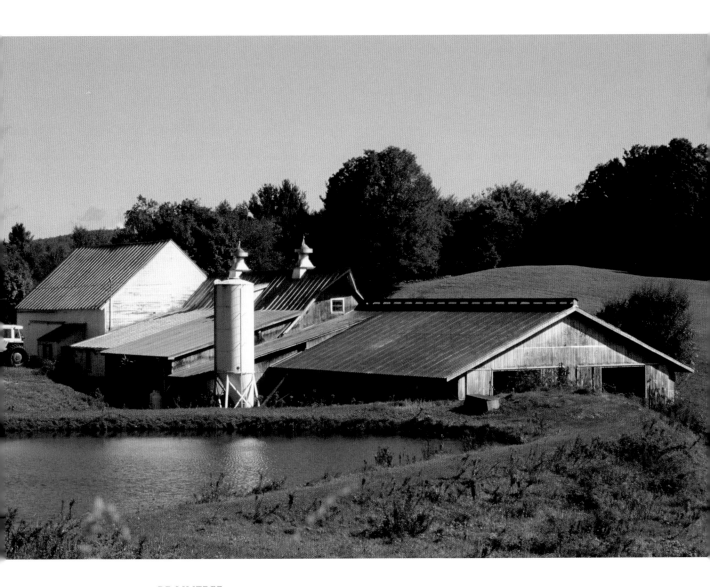

BRAINTREE
Vermont

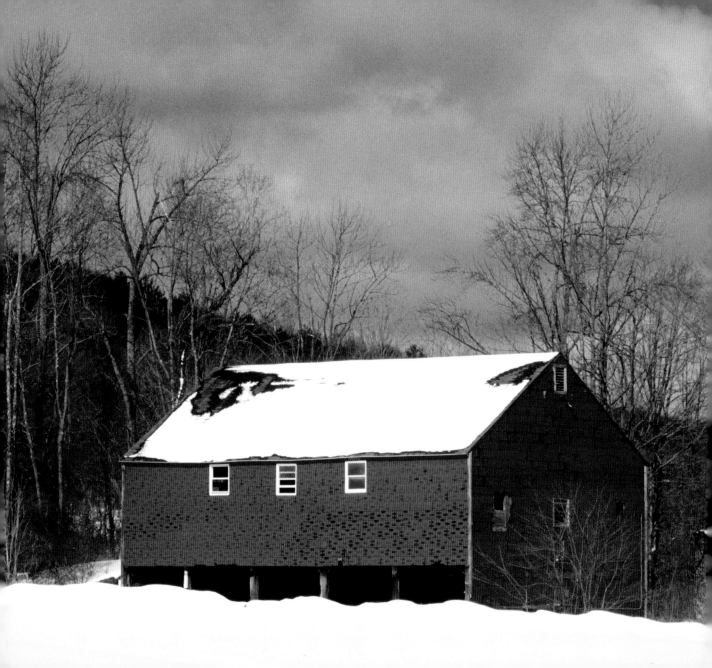

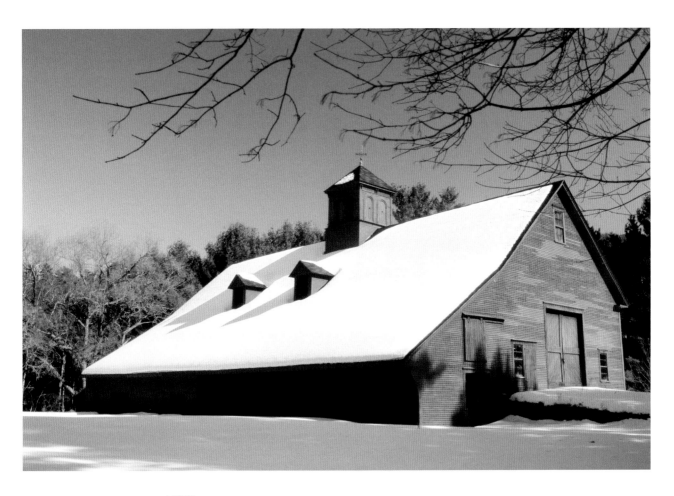

ABOVE
CORNISH
New Hampshire

———

OPPOSITE
LEBANON
New Hampshire

19

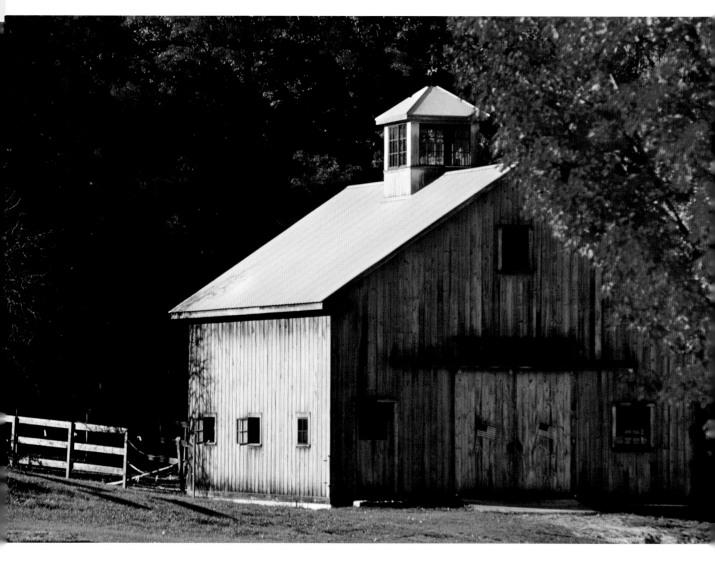

NEW LONDON
New Hampshire

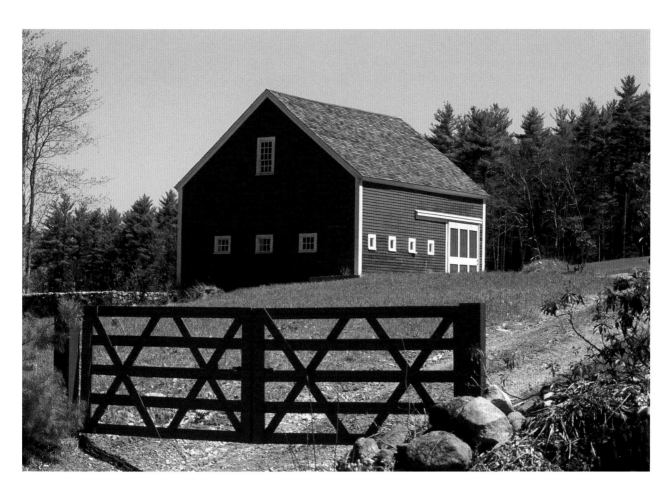

WEBSTER
New Hampshire

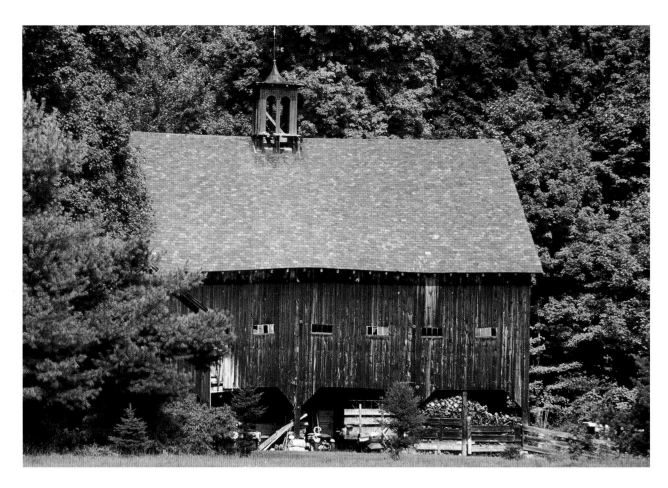

GREENFIELD
Massachusetts

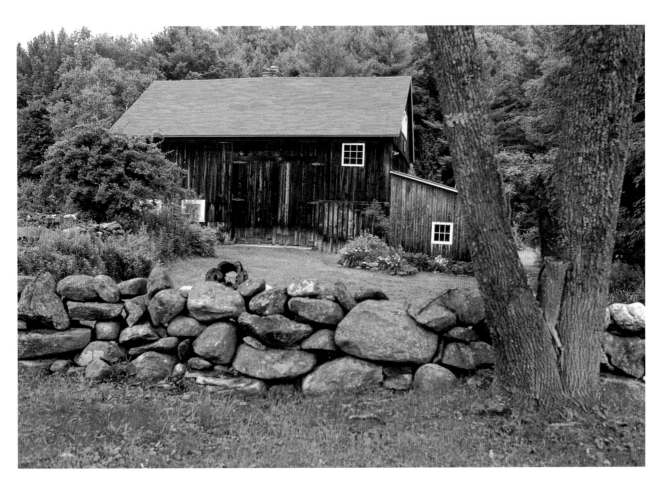

GRAFTON
Vermont

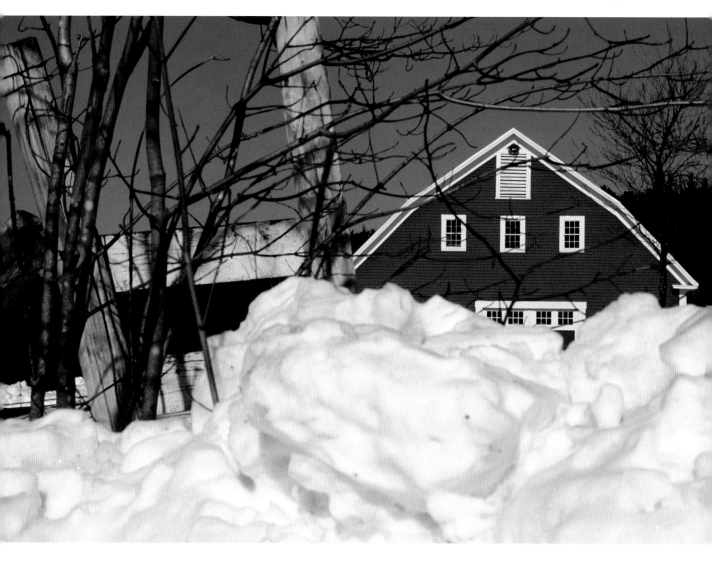

WILMOT
New Hampshire

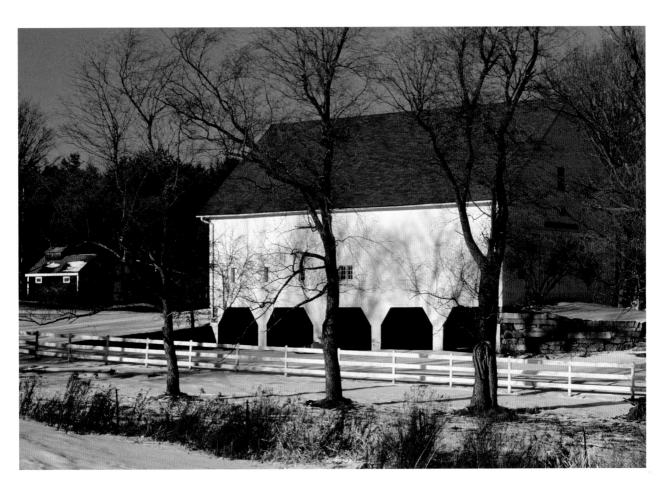

NEW LONDON
New Hampshire

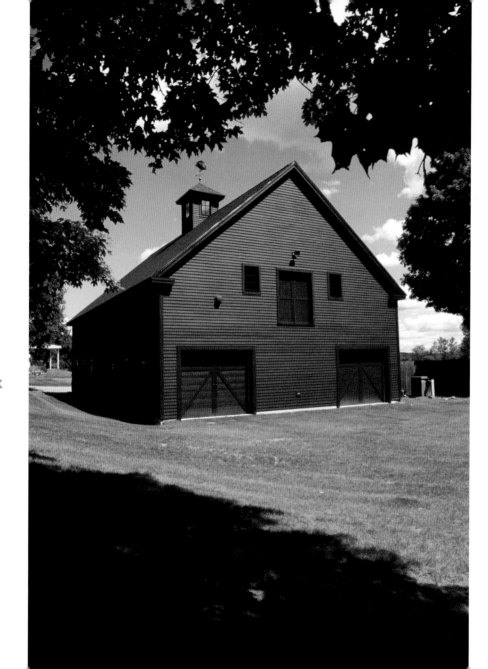

CONTOOCOOK
New Hampshire

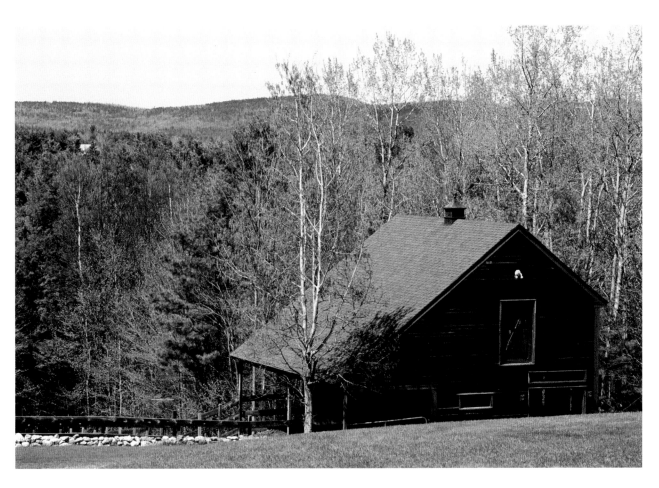

NORTH SUTTON
New Hampshire

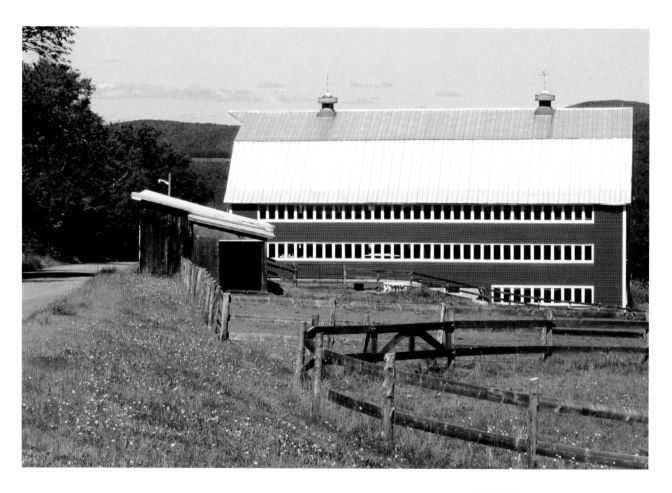

MONROE
New Hampshire

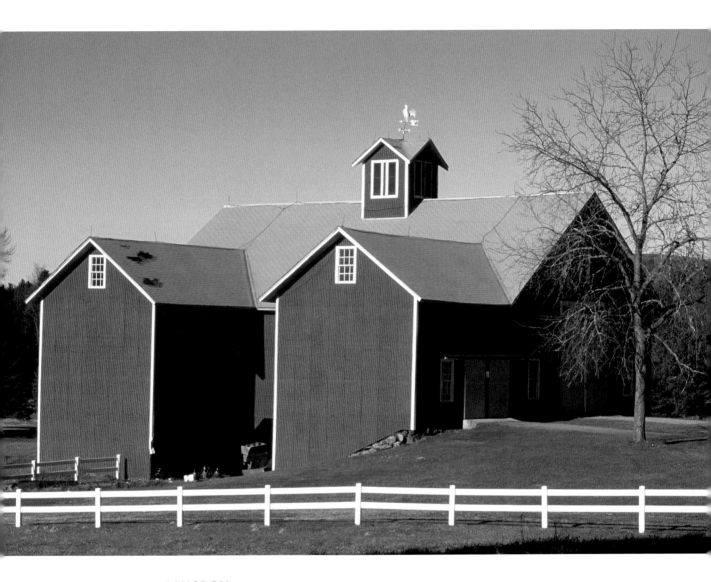

LANGDON
New Hampshire

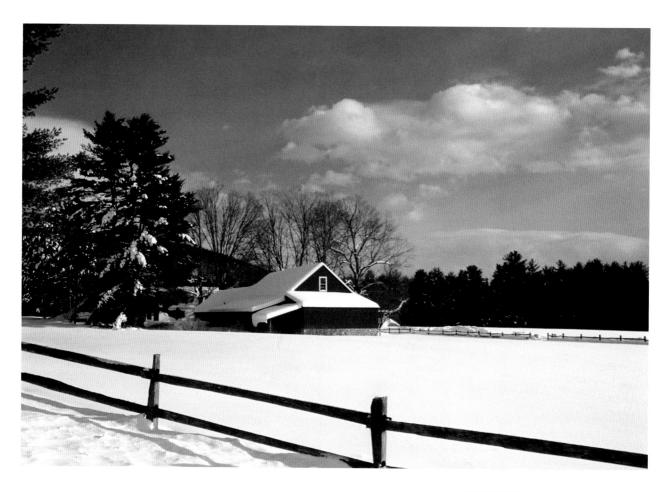

WEBSTER
New Hampshire

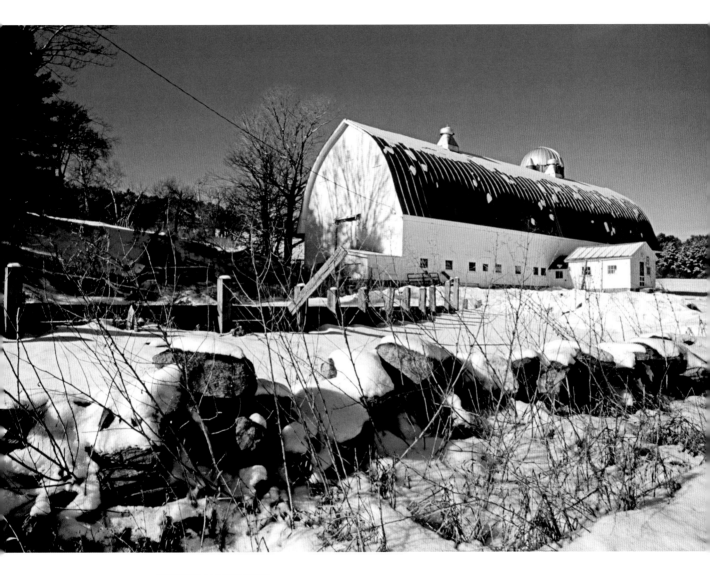

NORTH HARTLAND
Vermont

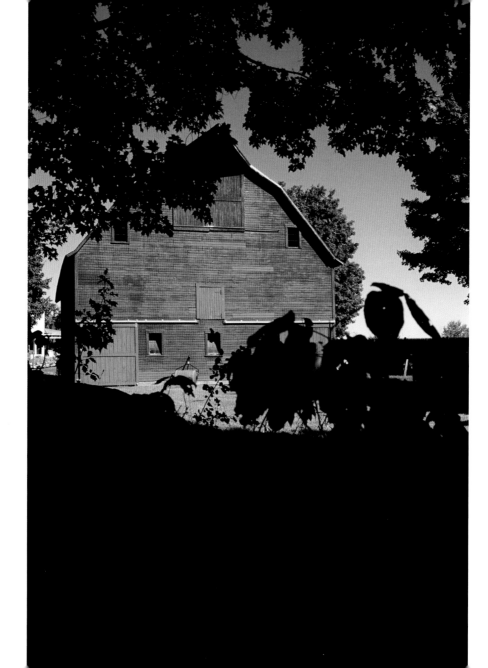

HOPKINTON
New Hampshire

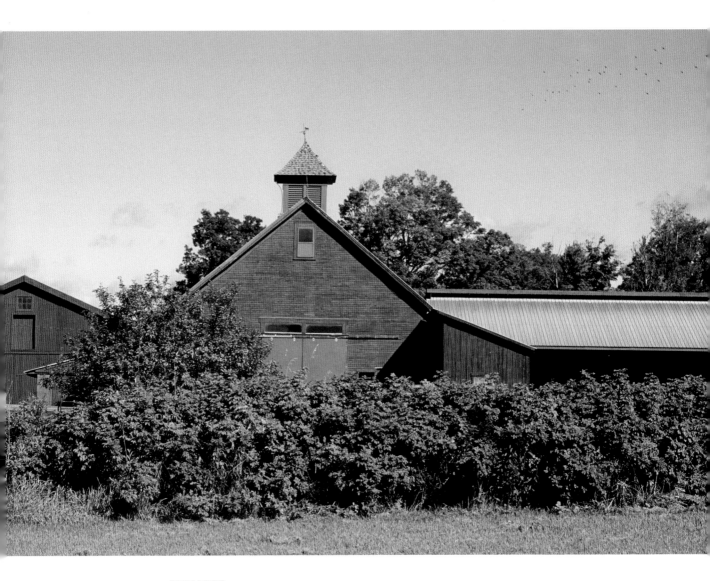

SUNAPEE
New Hampshire

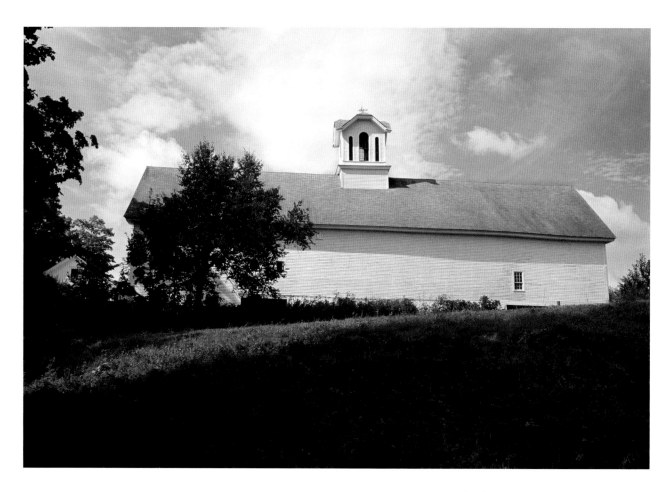

ANDOVER
New Hampshire

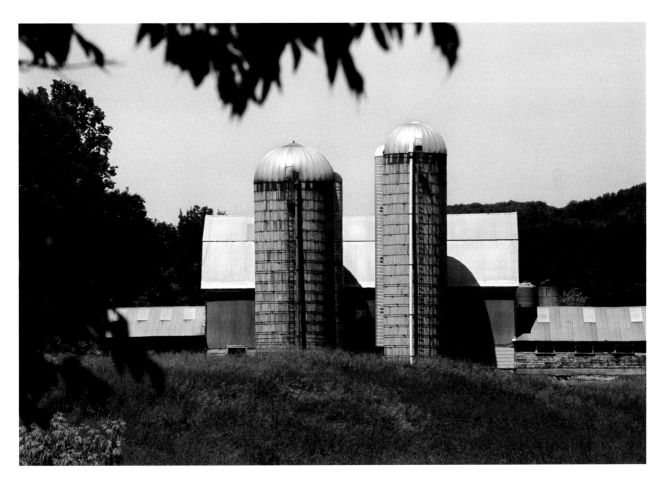

RANDOLPH
Vermont

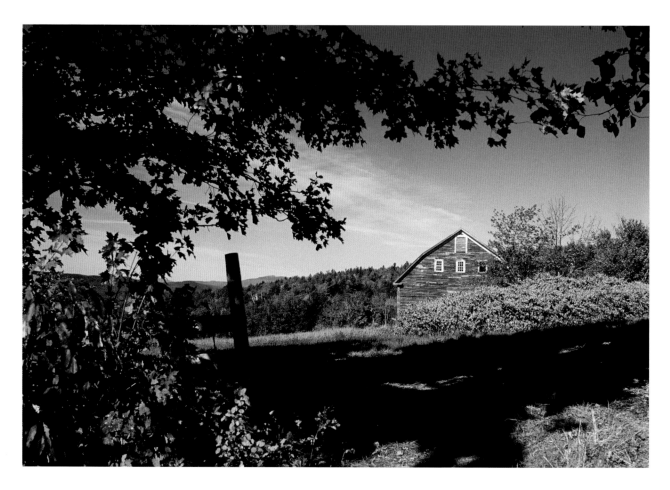

WILMOT
New Hampshire

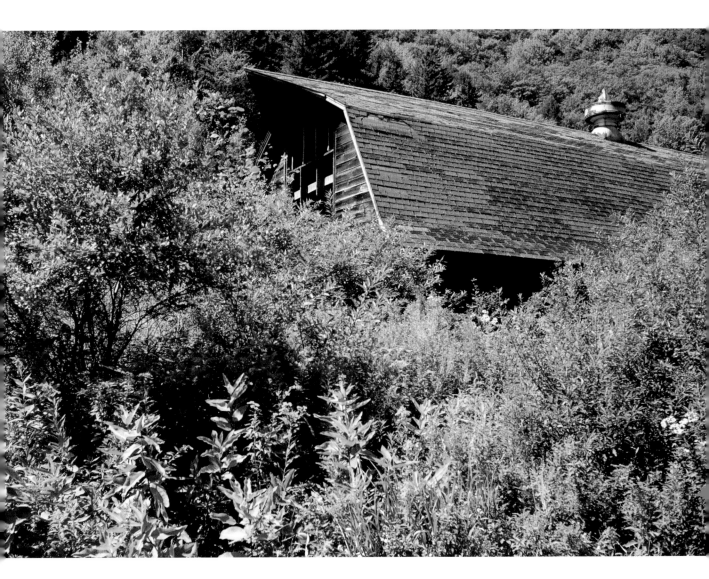

KILLINGTON
Vermont

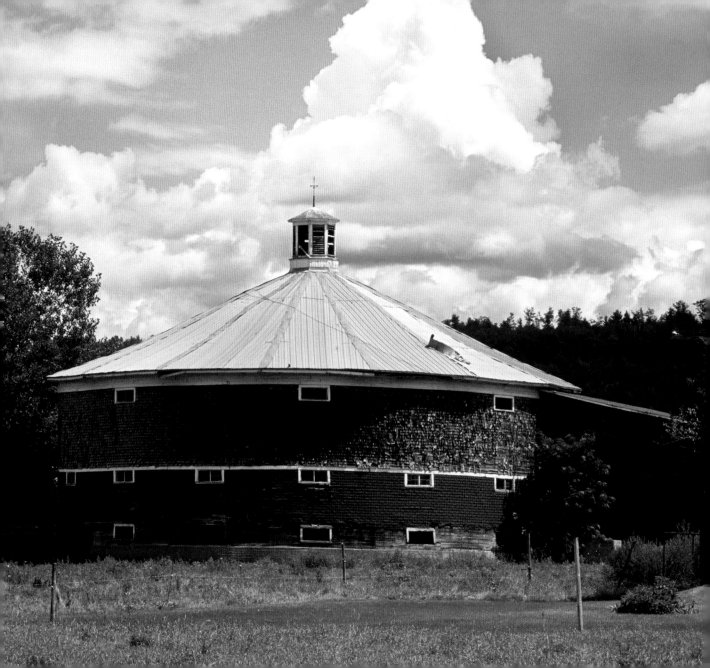

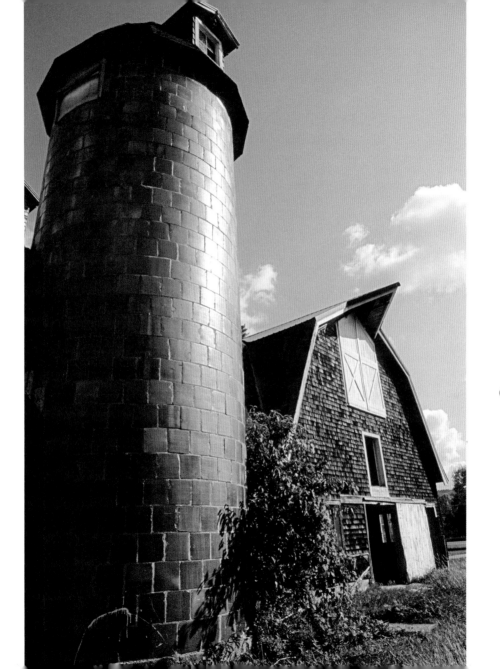

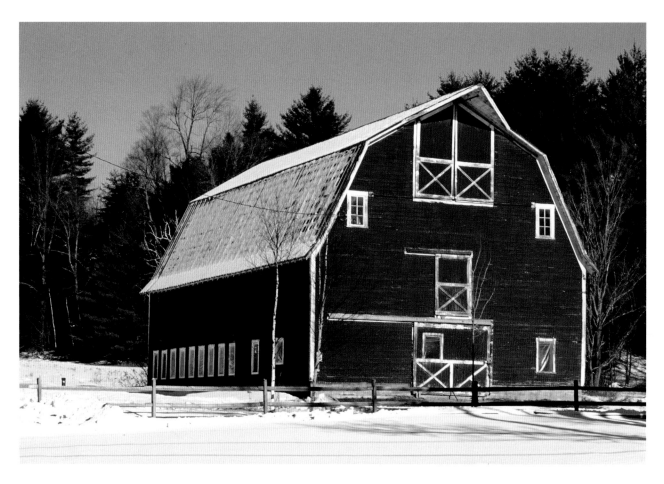

LUDLOW
Vermont

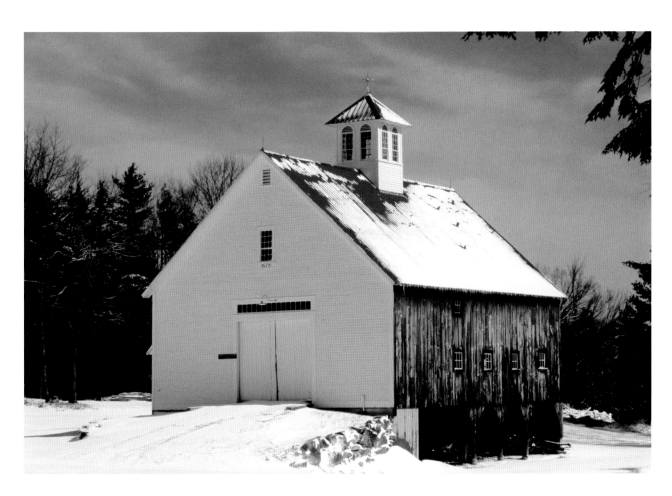

SUTTON
New Hampshire

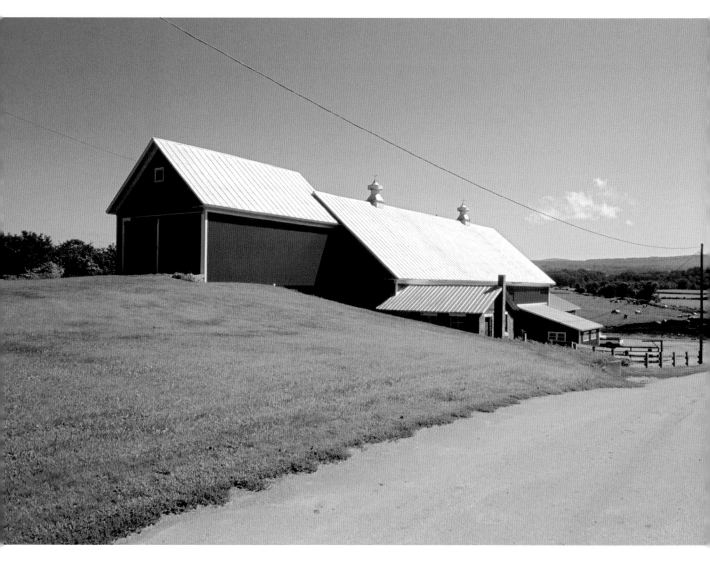

NEWBURY
Vermont

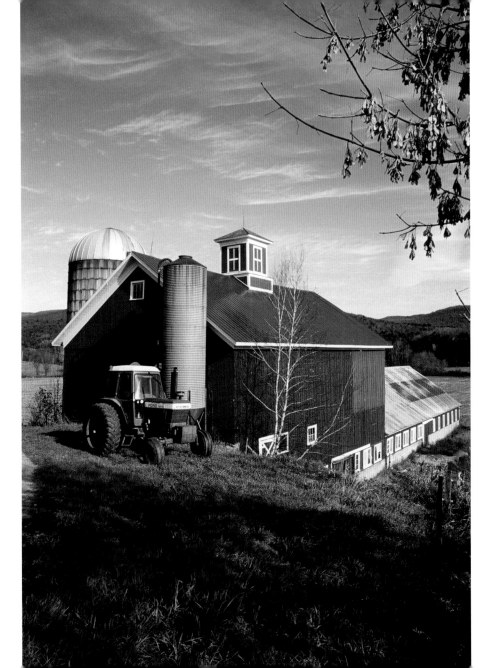

WATERVILLE
Vermont

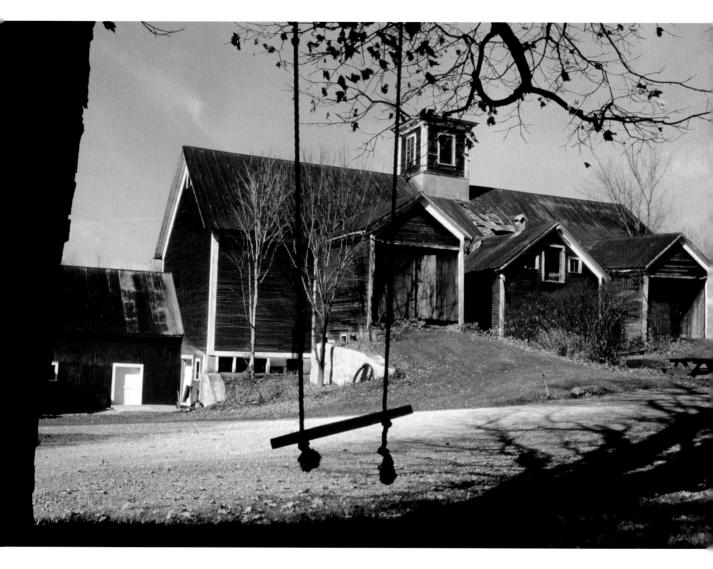

HYDE PARK
Vermont

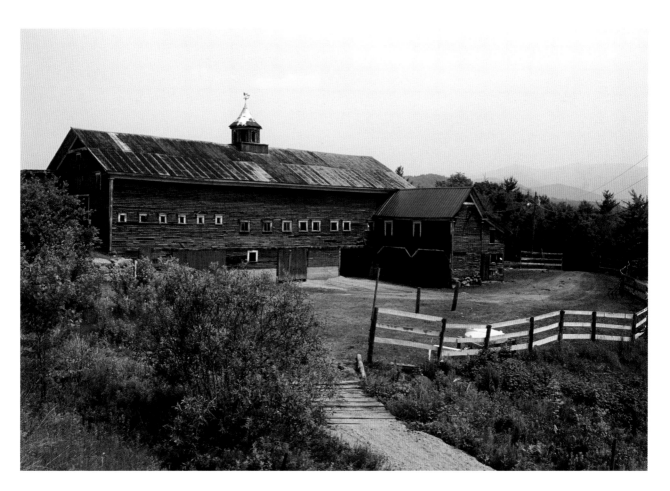

THORNTON
New Hampshire

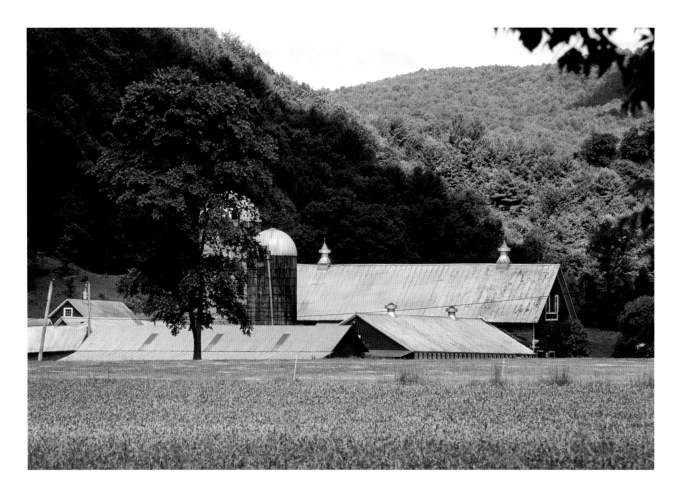

SOUTH ROYALTON
Vermont

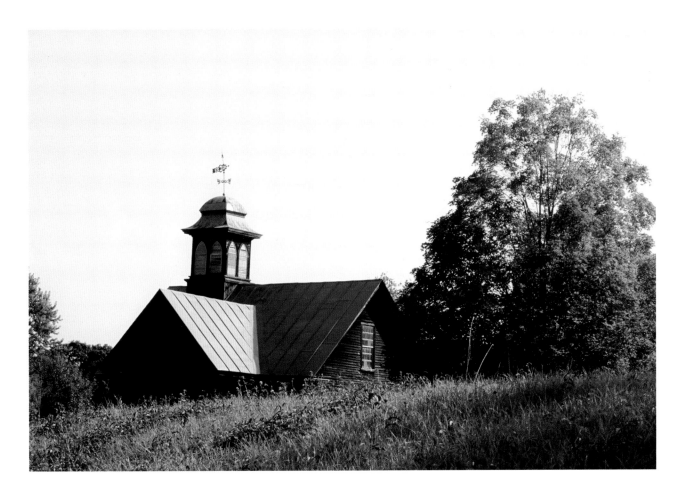

HARTLAND
Vermont

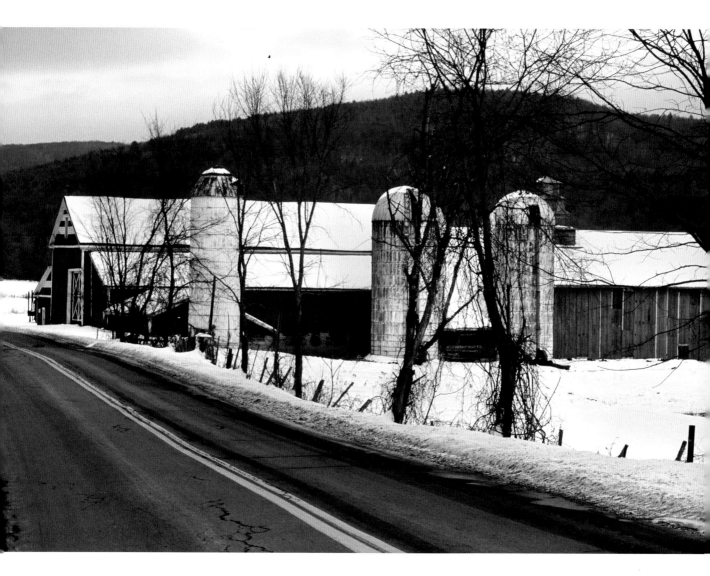

GRAFTON
Vermont

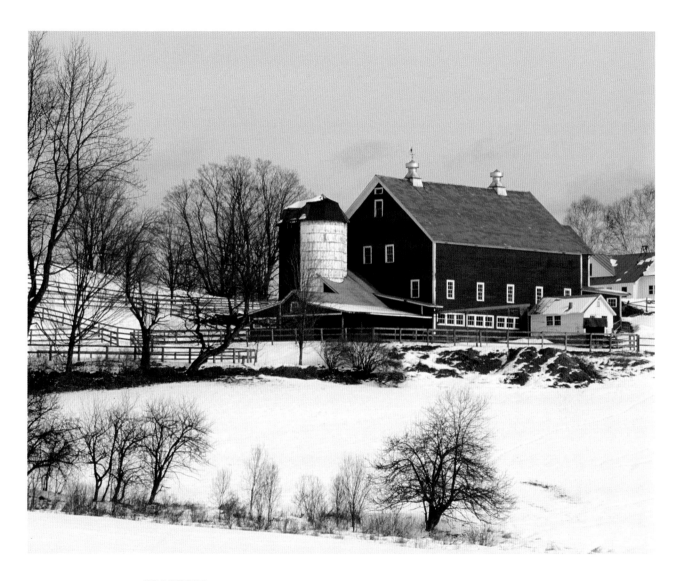

BRADFORD
Vermont

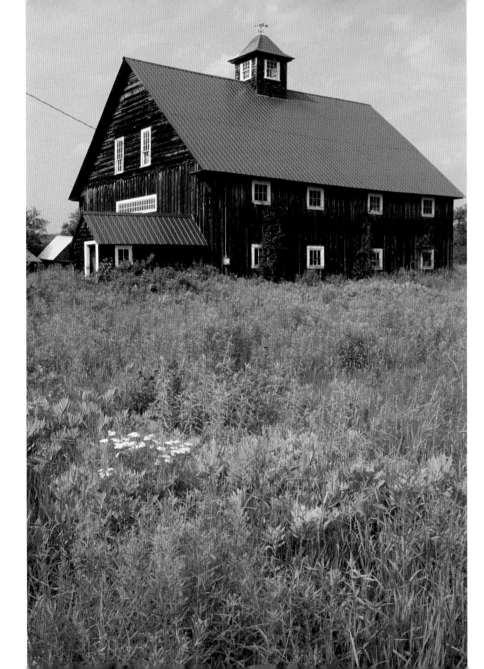

LIMINGTON
Maine

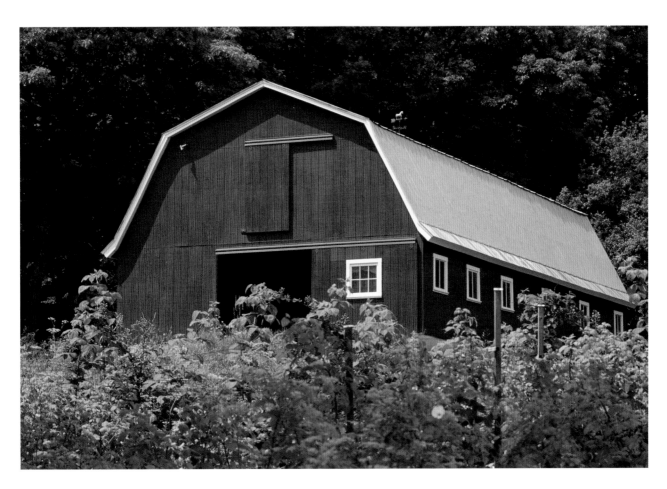

HARTLAND
Vermont

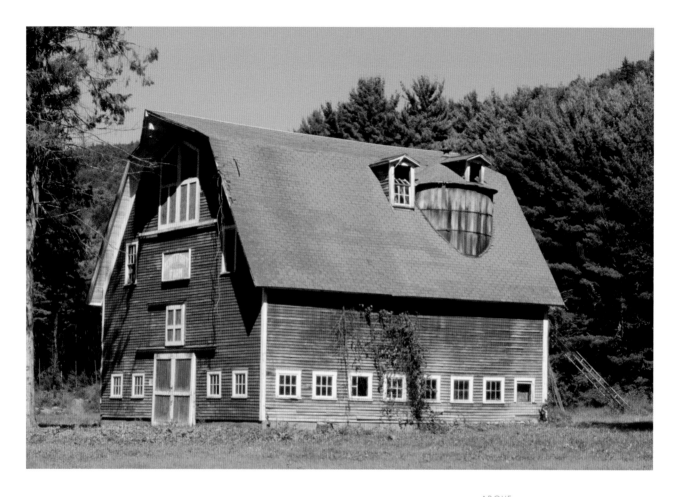

ABOVE
ORFORD
New Hampshire

———

OPPOSITE
STRAFFORD
New Hampshire

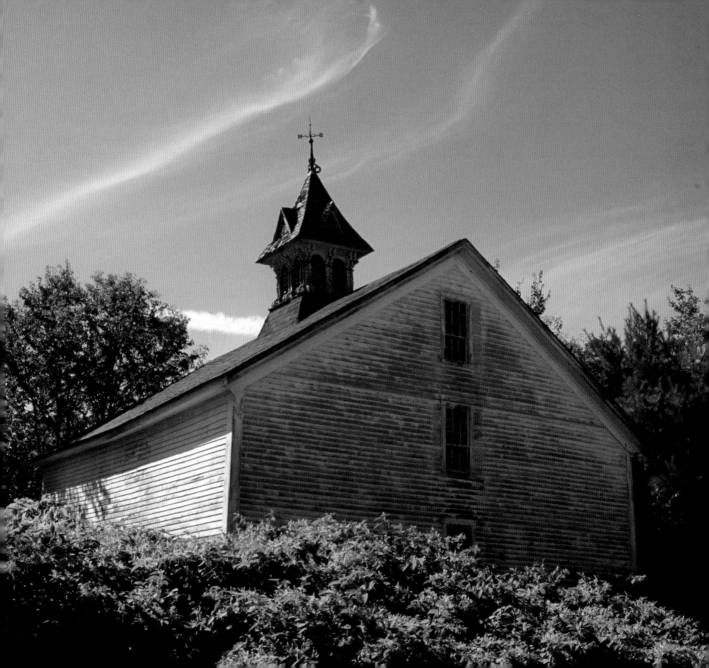

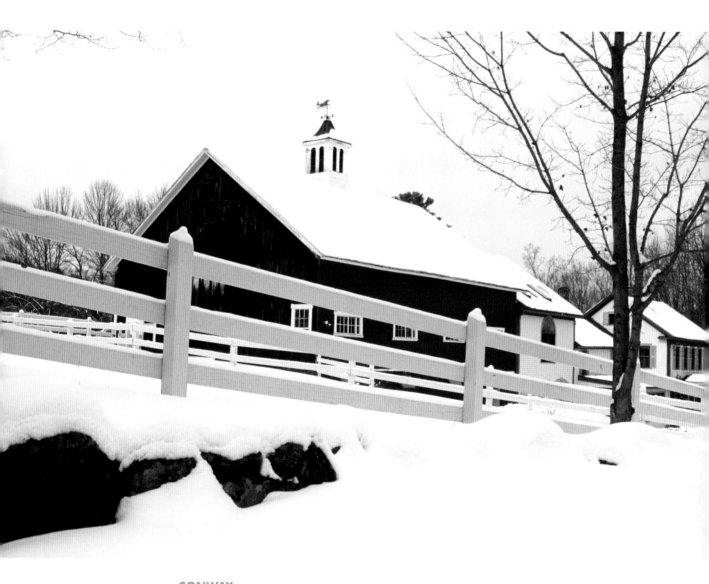

CONWAY
Massachusetts

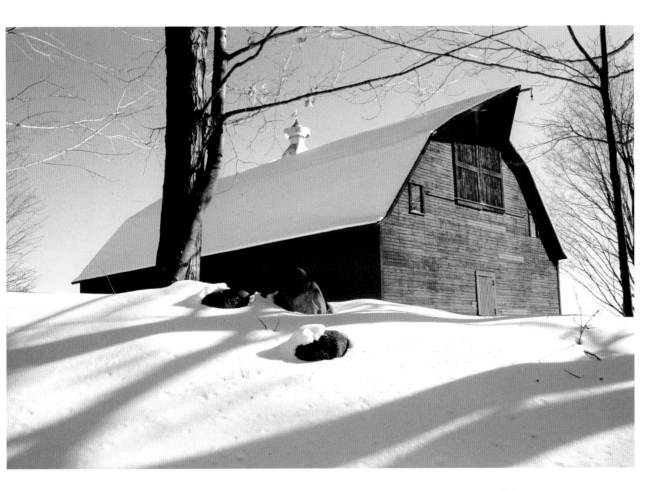

MERRIMACK
New Hampshire

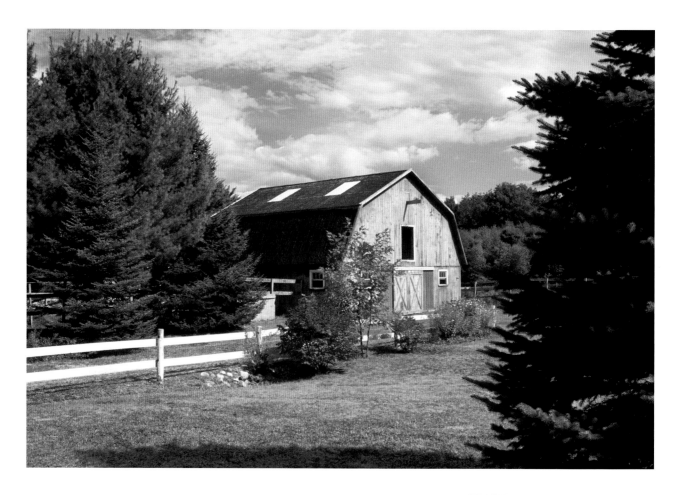

WARNER
New Hampshire

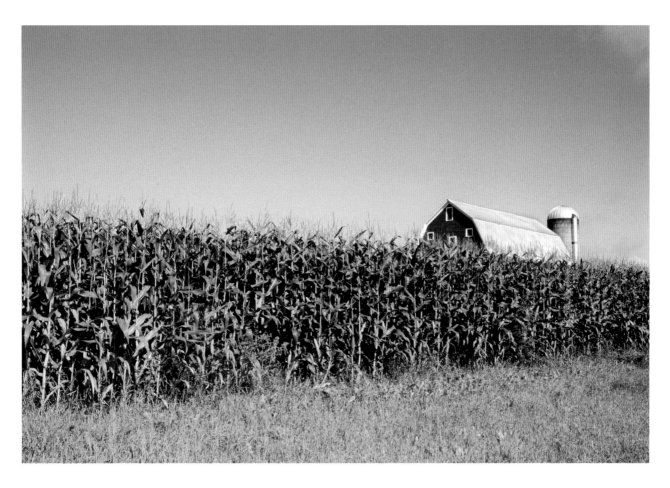

FAIRLEE
Vermont

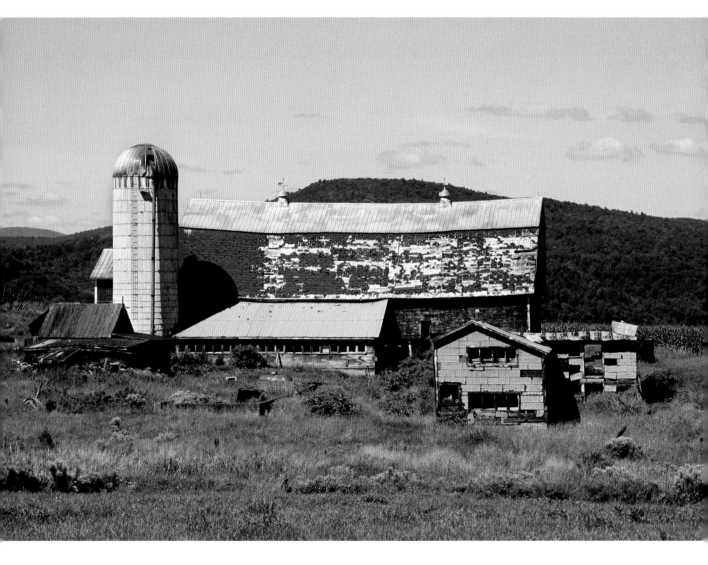

MONROE
New Hampshire

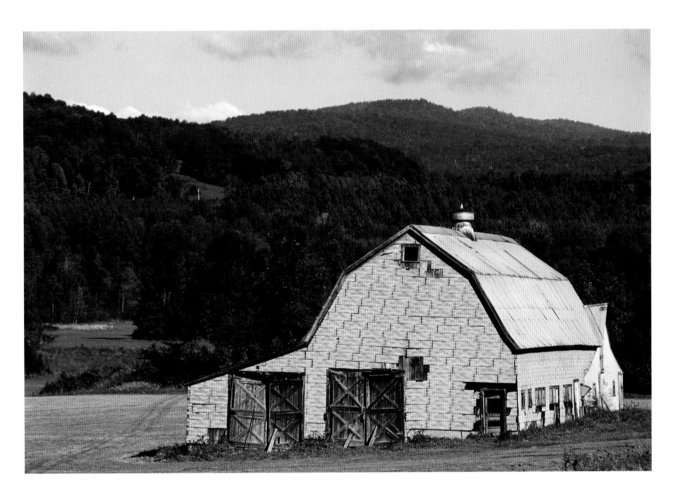

RANDOLPH
Vermont

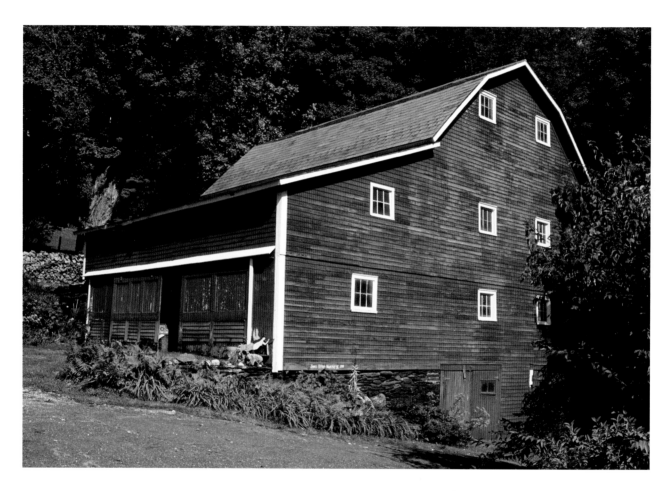

CHARLEMONT
Massachusetts

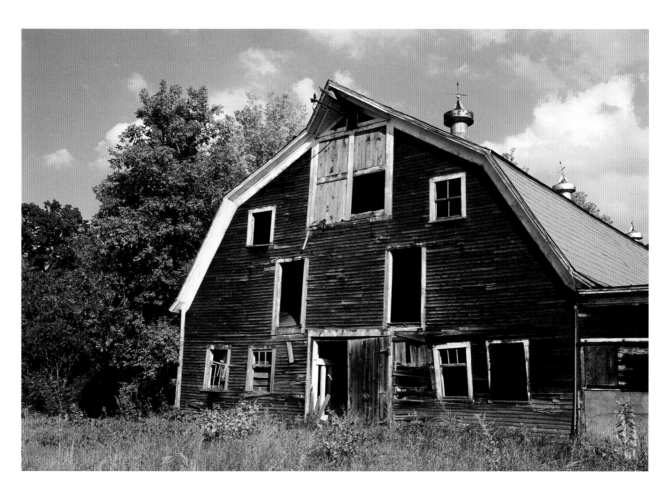

WINDSOR
Vermont

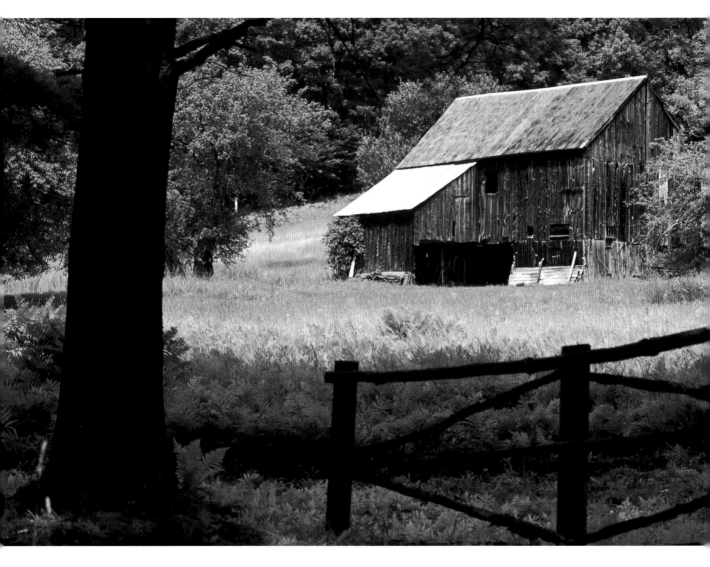

HARTLAND
Vermont

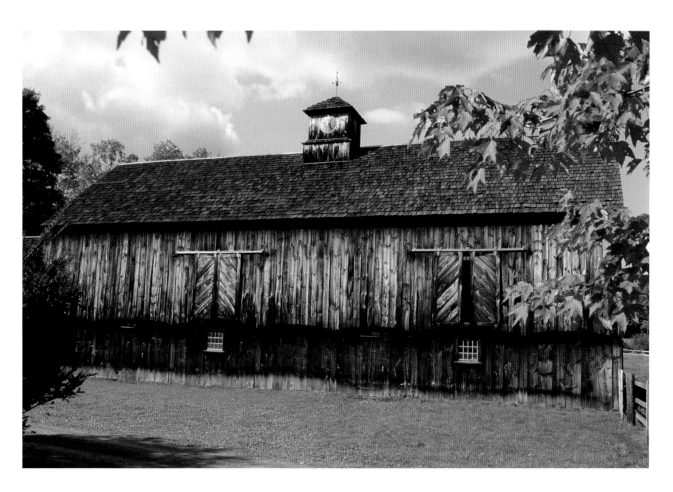

CHARLEMONT
Massachusetts

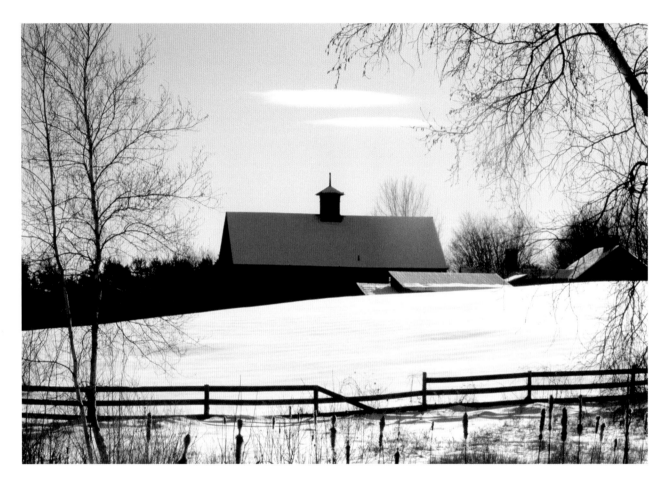

NEW LONDON
New Hampshire

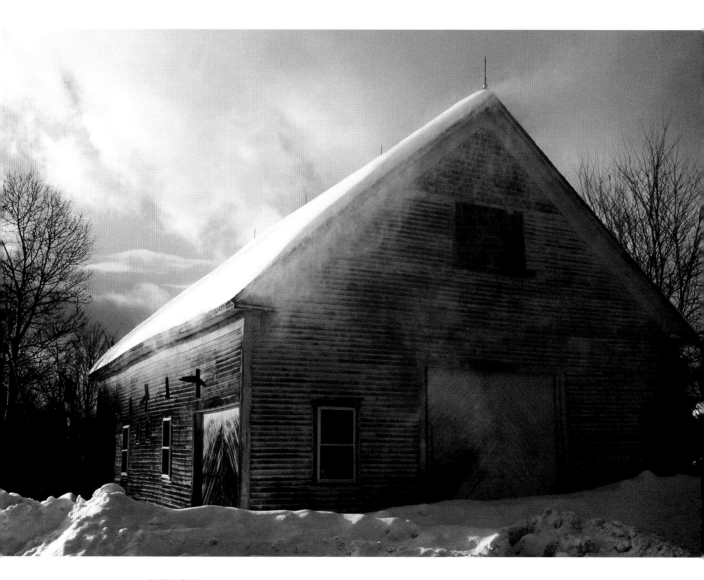

LUDLOW
Vermont

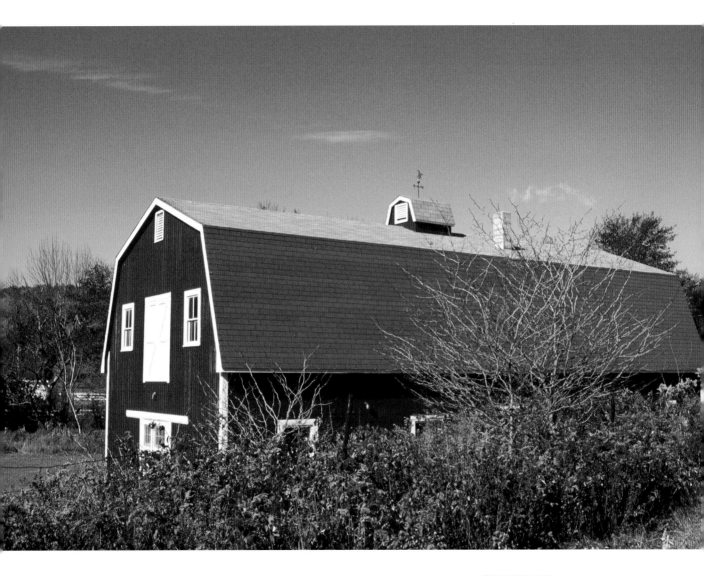

GRANTHAM
New Hampshire

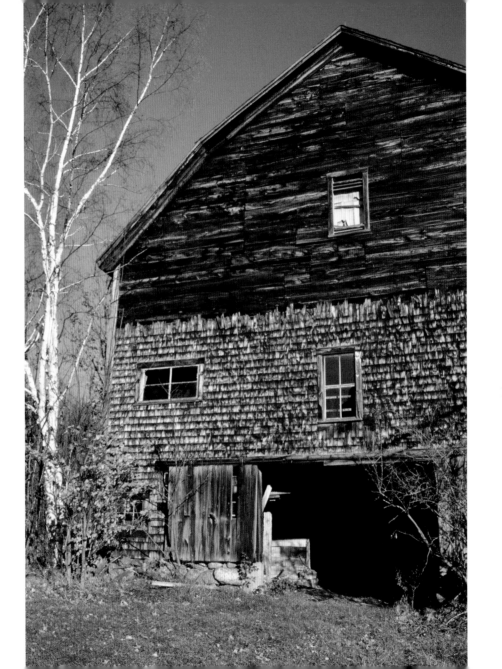

WILMOT
New Hampshire

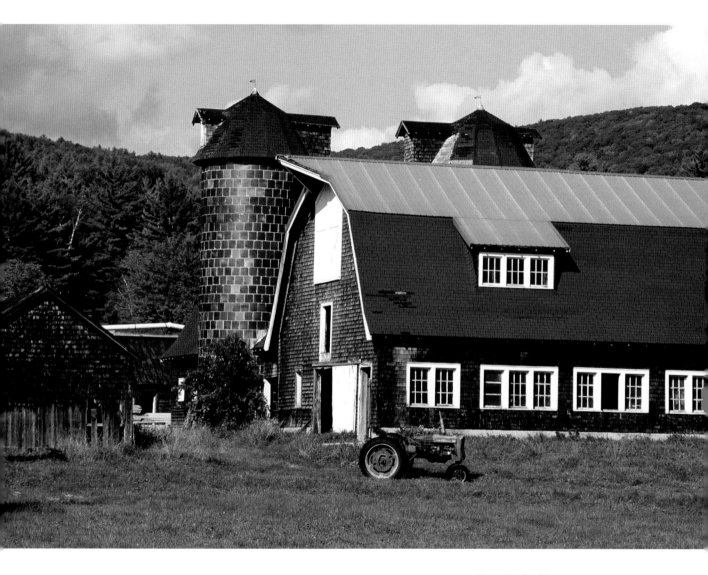

CLAREMONT
New Hampshire

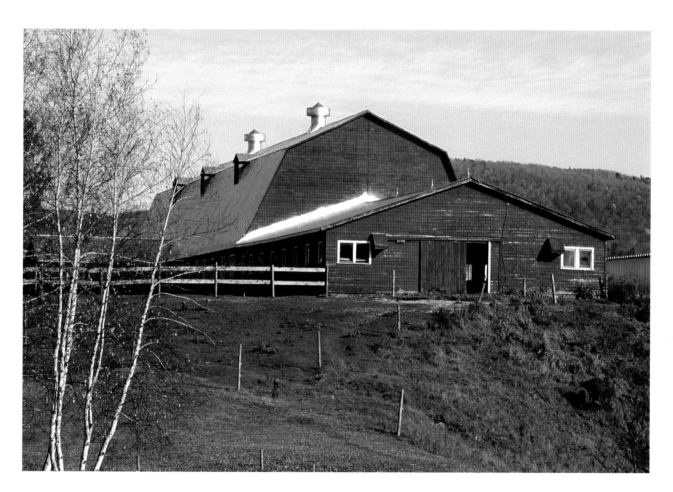

MORRISVILLE
Vermont

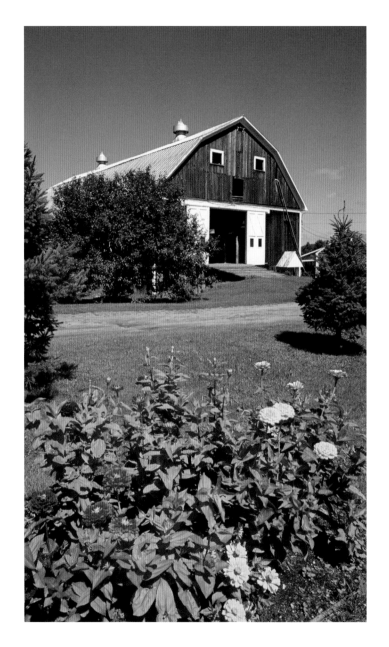

MONROE
New Hampshire

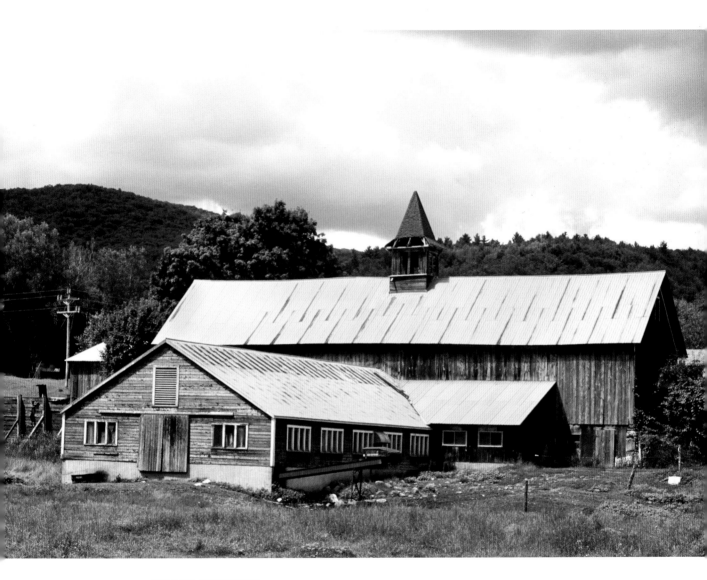

NORTH THETFORD
Vermont

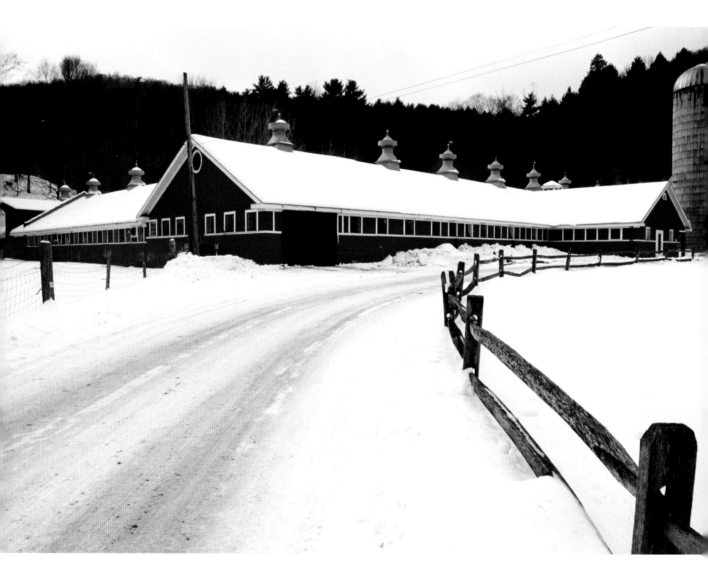

BRATTLEBORO
Vermont

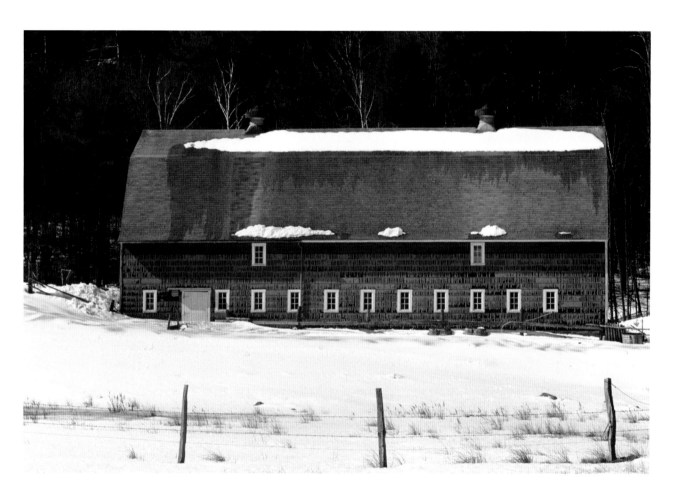

ANDOVER
New Hampshire

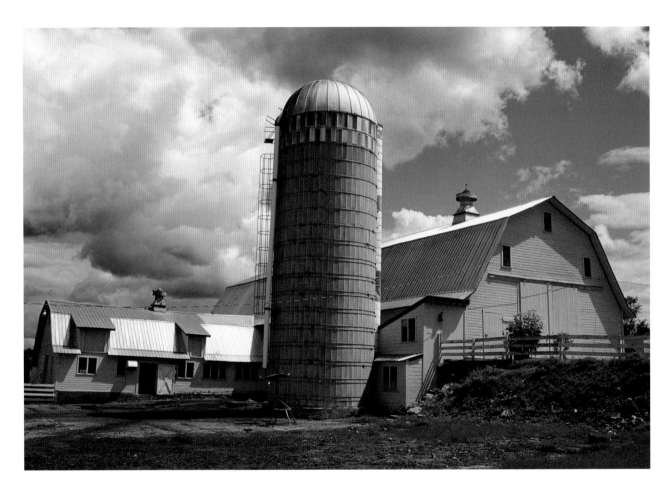

FAIRLEE
Vermont

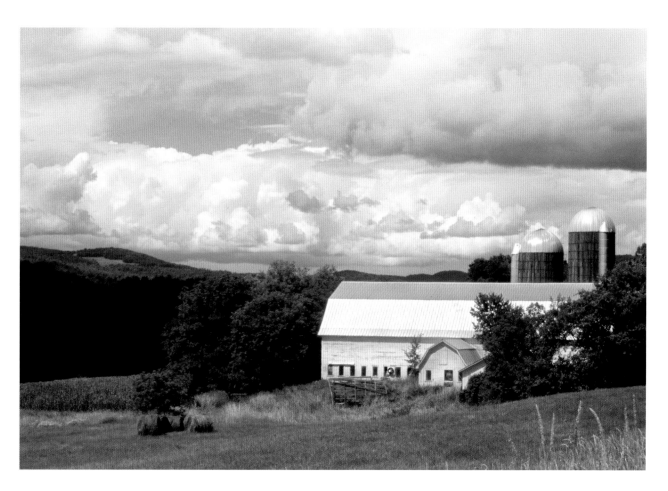

TINKERVILLE
New Hampshire

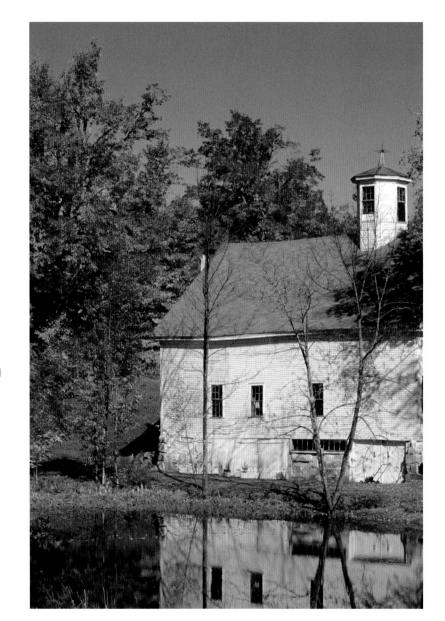

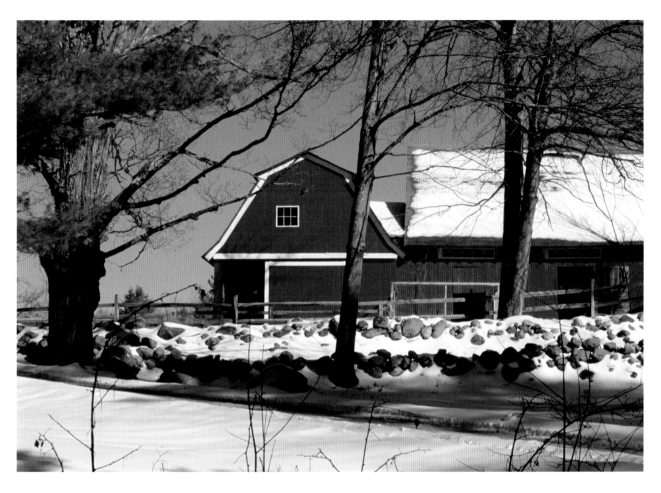

SUTTON
New Hampshire

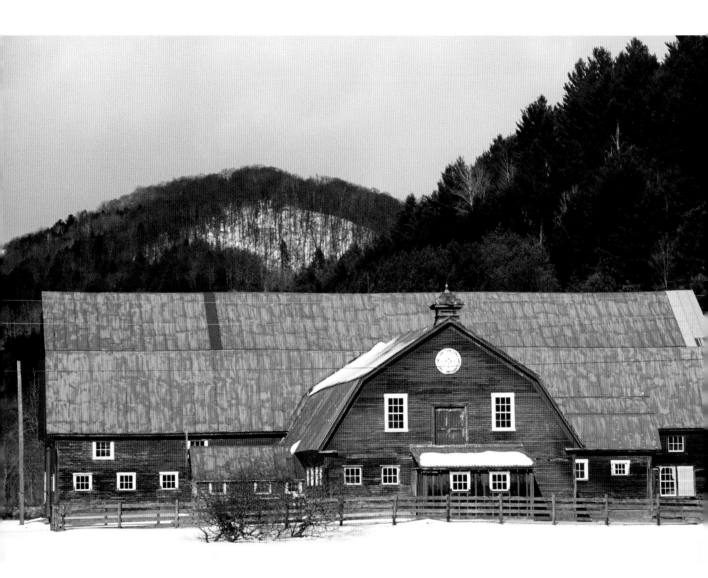

SOUTH POMFRET
Vermont

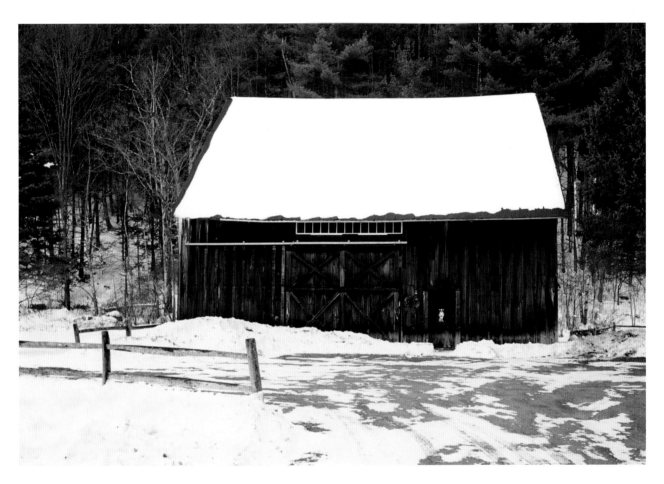

GRAFTON
Vermont

HARTLAND
Vermont

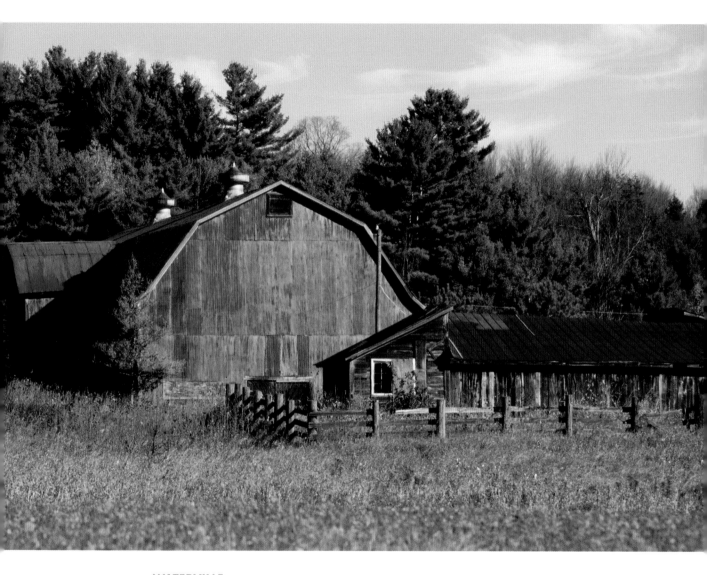

WATERVILLE
Vermont

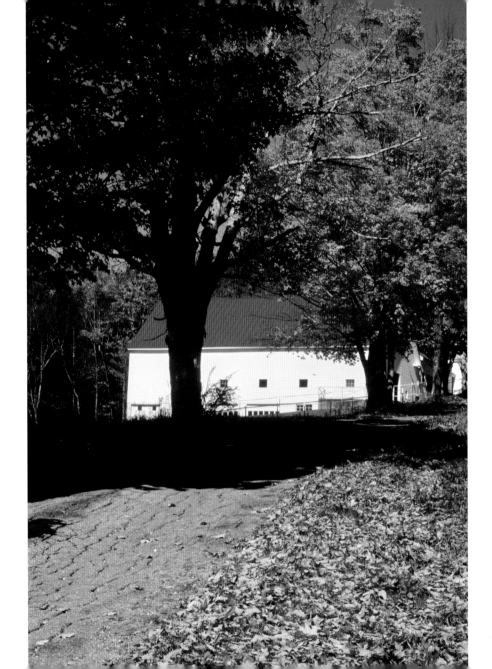

ANDOVER
New Hampshire

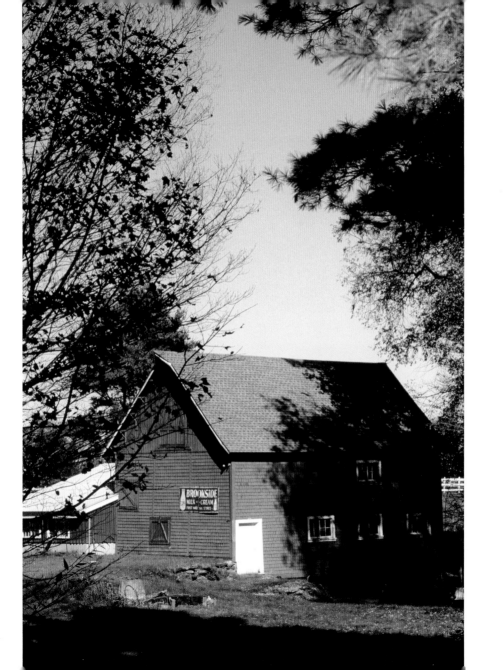

WATERBURY
Vermont

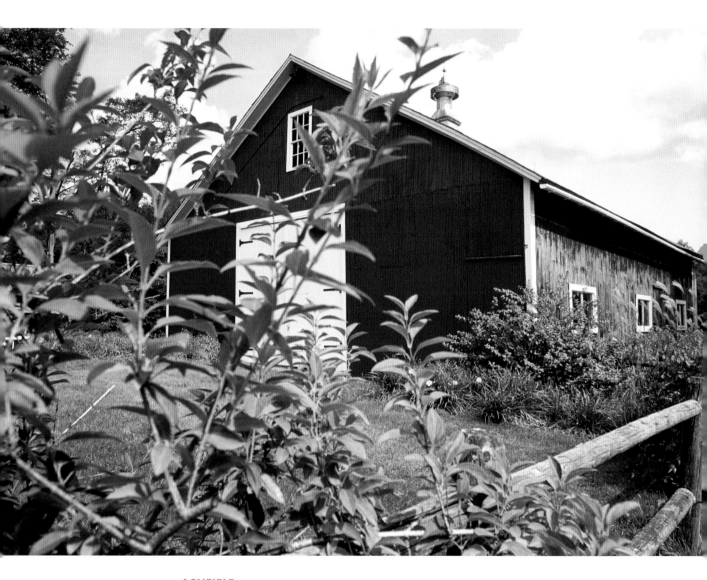

ASHFIELD
Massachusetts

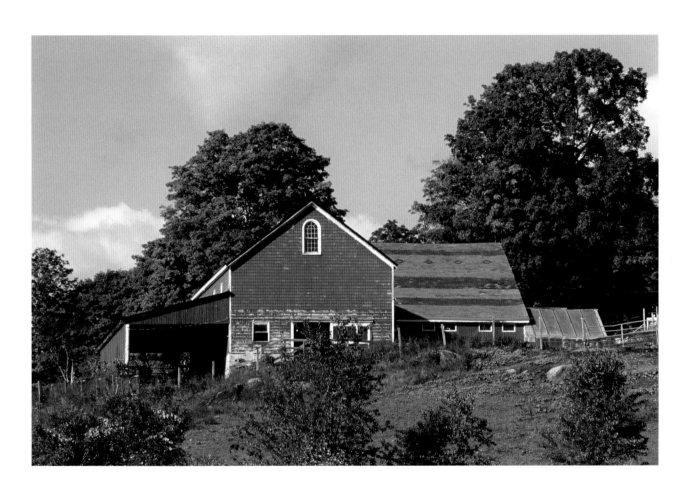

CONWAY
Massachusetts

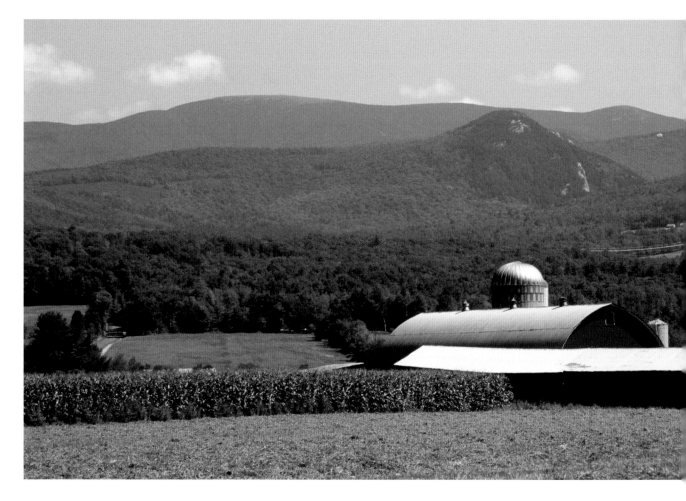

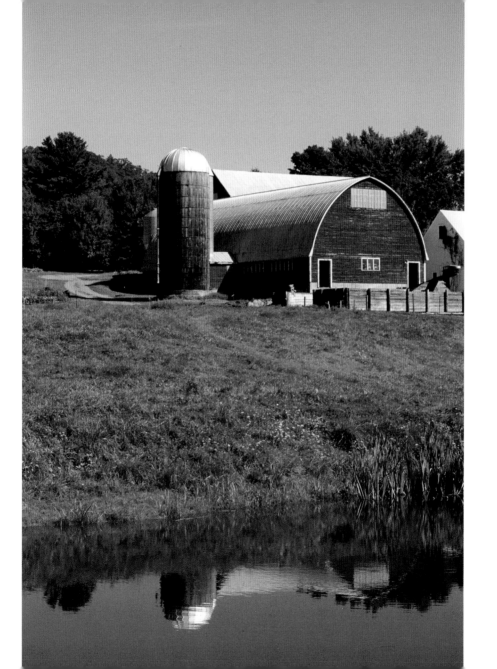

BRADFORD
Vermont

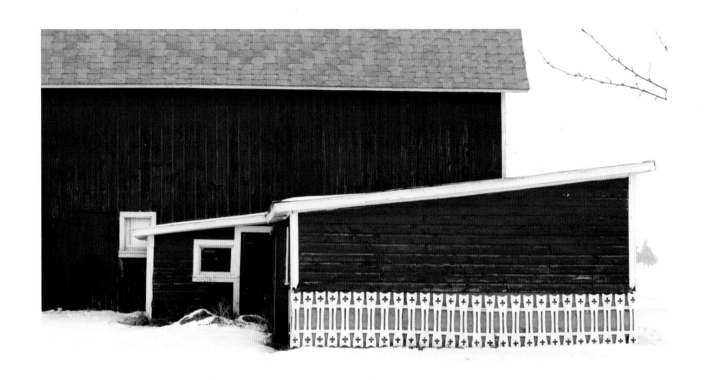

NORWALK
Connecticut

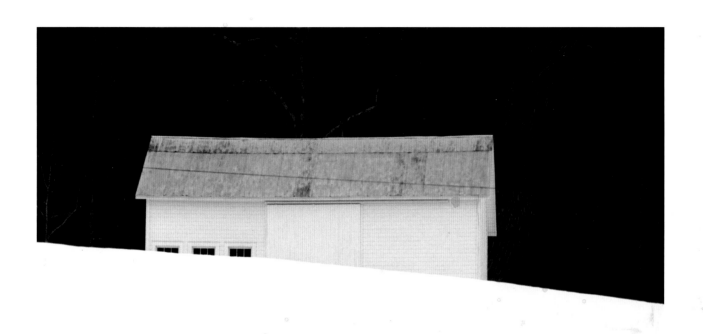

BARRE
Vermont

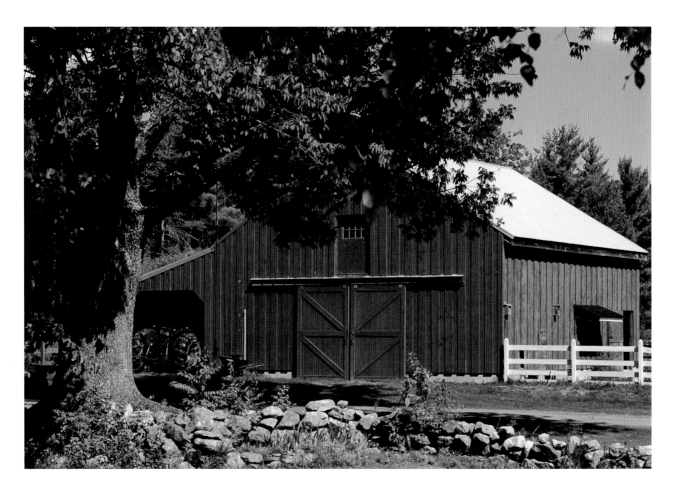

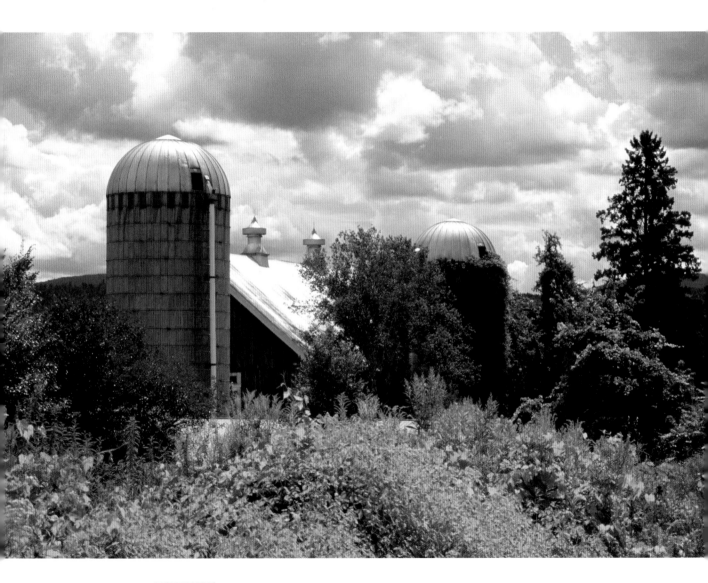

NEWBURY
Vermont

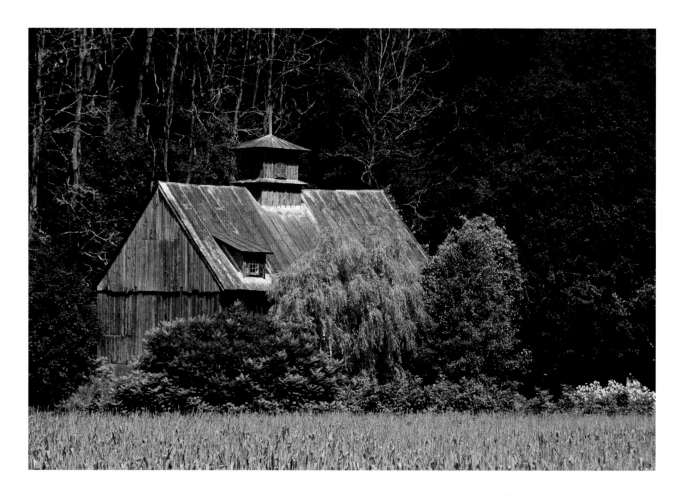

ABOVE
FAIRLEE
Vermont

OPPOSITE
ASHFIELD
Massachusetts

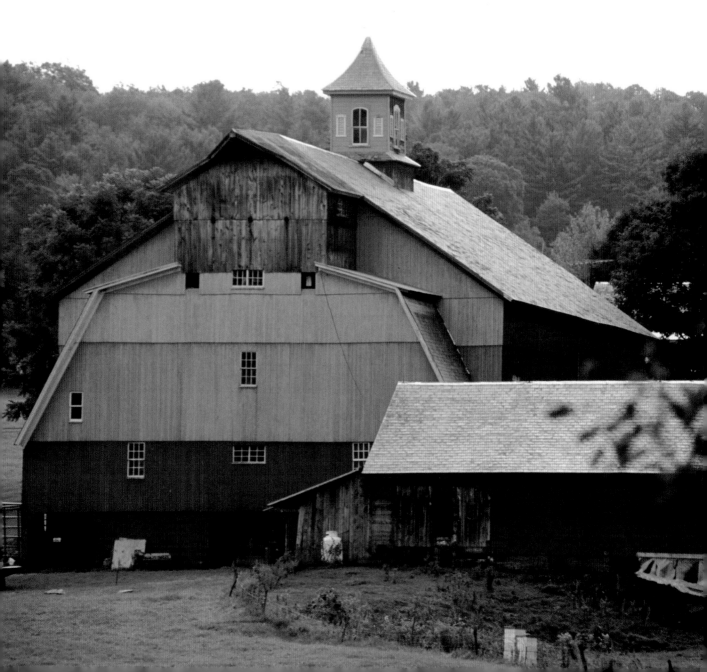

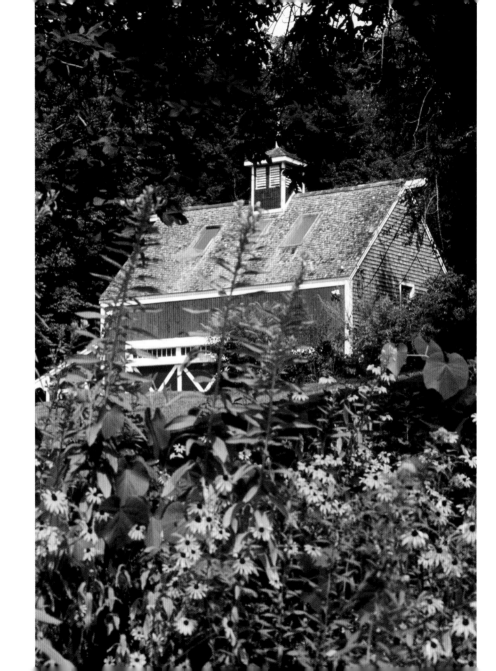

BOXFORD
Massachusetts

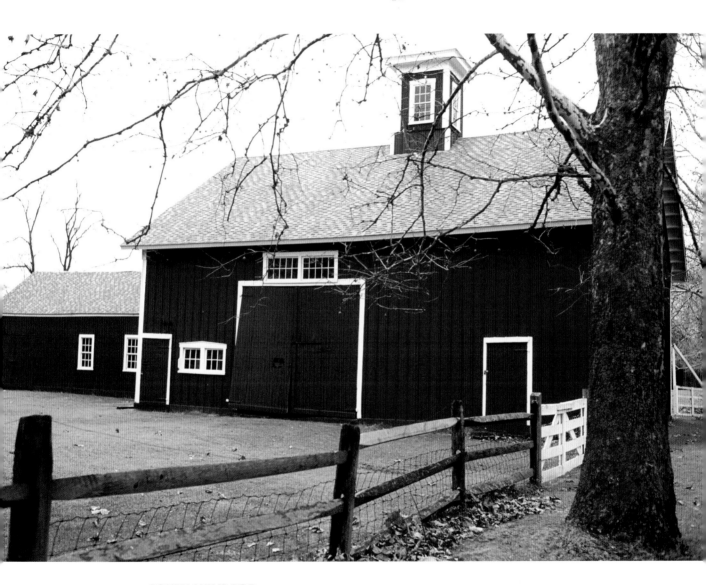

SOUTH WINDSOR
Connecticut

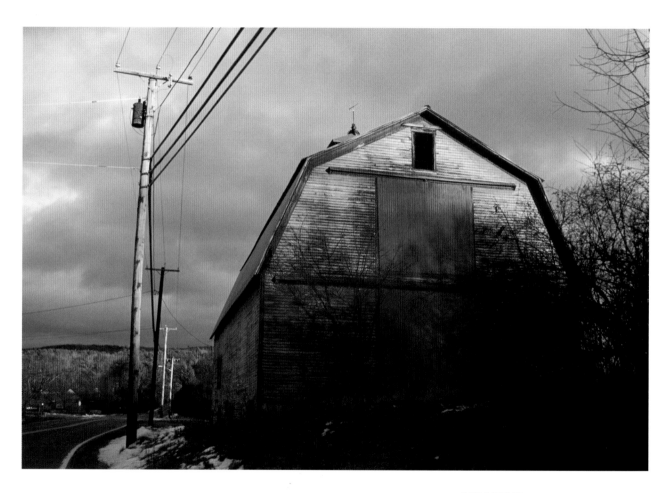

LEBANON
New Hampshire